DOG DAYS

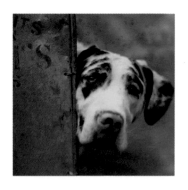

DOG DAYS
a photographic celebration

MQ Publications Ltd

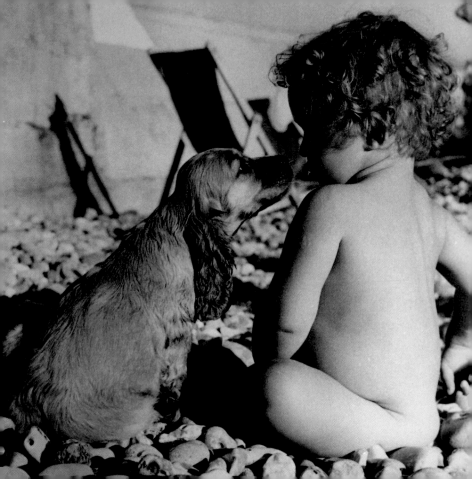

The greatest love is a mother's; then comes a dog's; then comes a sweetheart's.

Polish Proverb

Love me, love my dog.

Bernard of Clairvaux

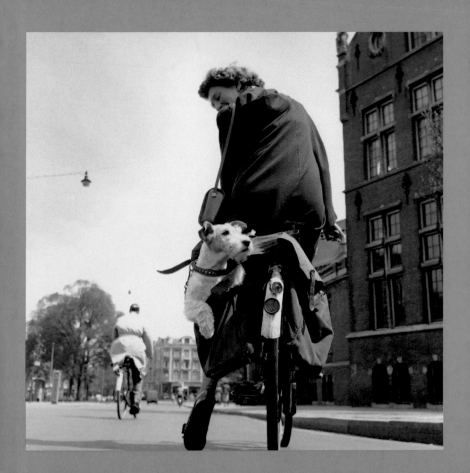

He does not say "Do" like my mother, or "Don't" like my father, or "Stop" like my big brother. My dog Spot and I sit together quietly and I like him and he likes me.

John Morrison, age 8

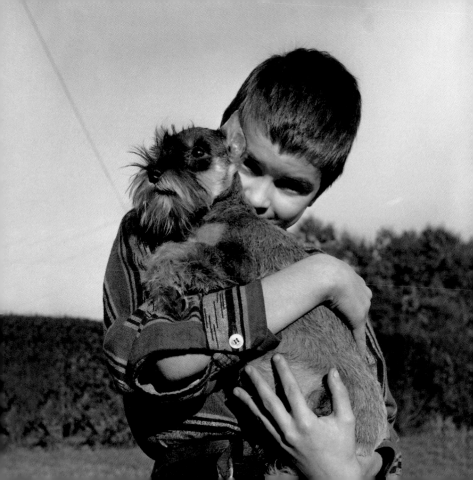

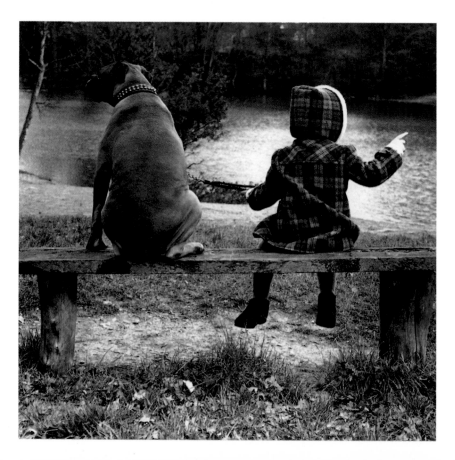

Life would be perfect, if it was just kids and dogs.

from "Homicide: Life on the Streets"

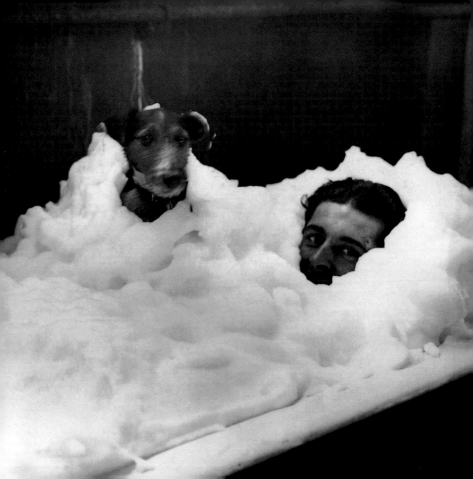

The greatest pleasure of a dog

is that you may make a fool of yourself

with him and not only will he

not scold you but he will make

a fool of himself too.

Samuel Butler

A reasonable amount o' fleas is good fer a dog

– keeps him from broodin' over bein' a dog.

<div align="right">*Edward Noyes Wescott*</div>

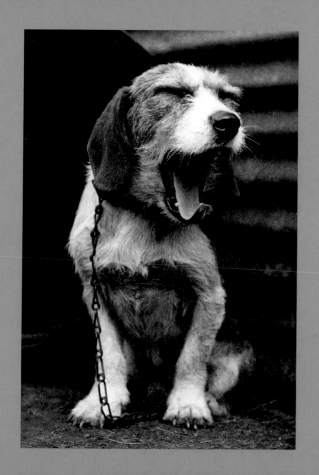

With eye uprais'd, his master's looks to scan,

The joy, the solace, and the aid of man;

The rich man's guardian, and the poor man's friend,

The only being faithful to the end.

George Crabbe, from "The Borough"

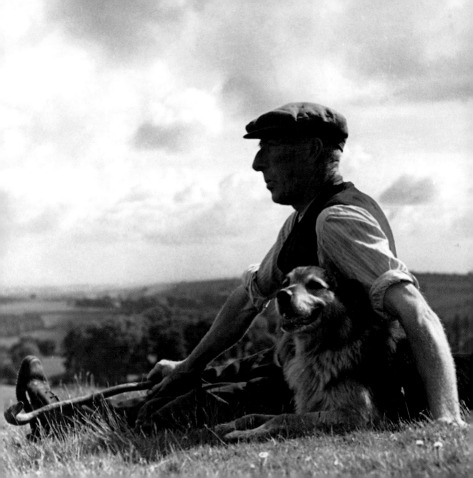

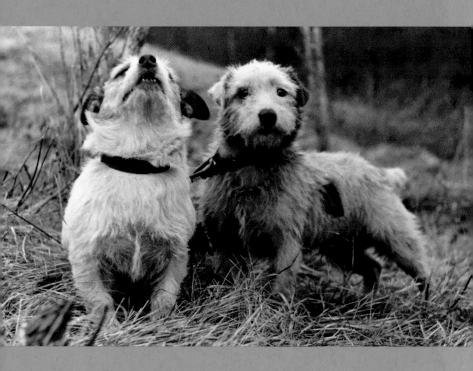

If only men could love each other like dogs,

the world would be paradise.

James Douglas

Four legs good, two legs bad.

George Orwell

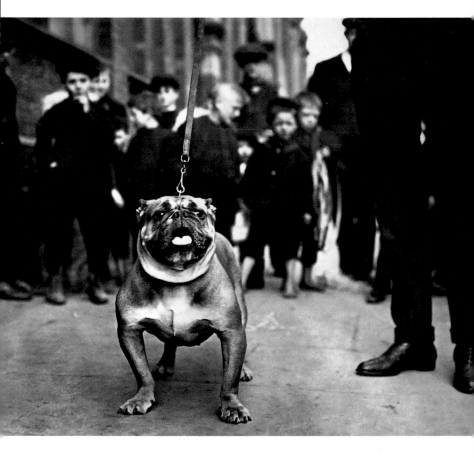

Let sleeping dogs lie

– who wants to rouse 'em?

Charles Dickens

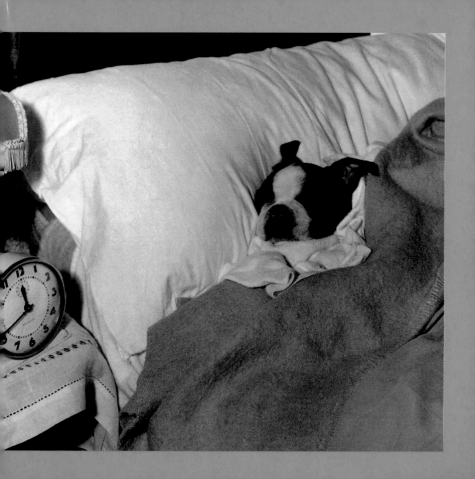

The poor dog,

in life the firmest friend

The first to welcome,

foremost to defend

Lord Byron

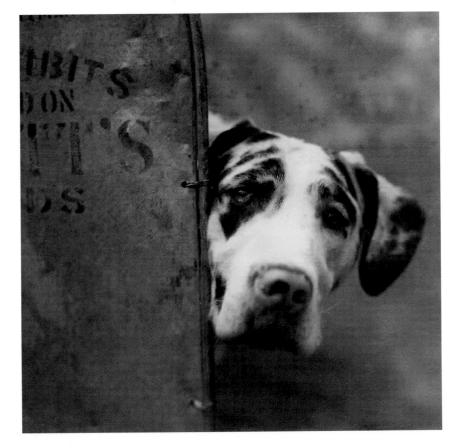

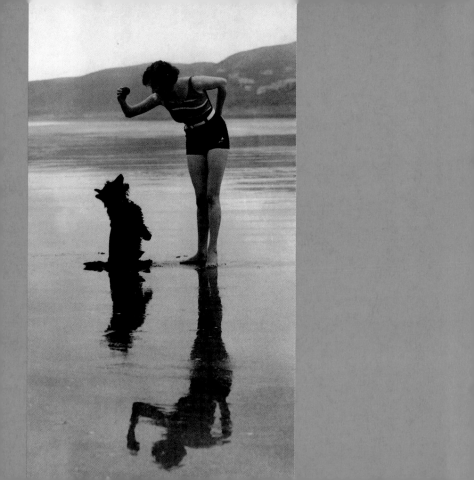

No one appreciates the very

special genius of your

conversation as a dog does.

Christopher Morely

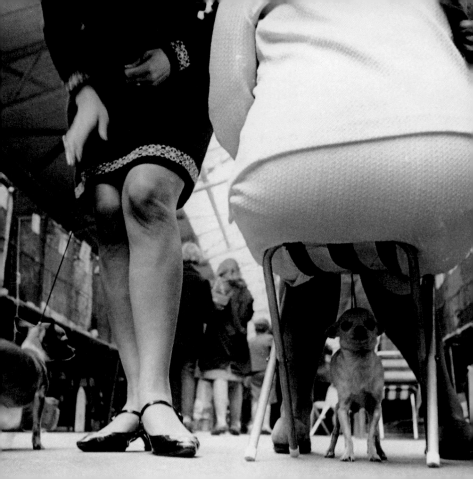

His bark is worse than his bite.

George Herbert

All animals are equal,

but some are more equal than others.

George Orwell

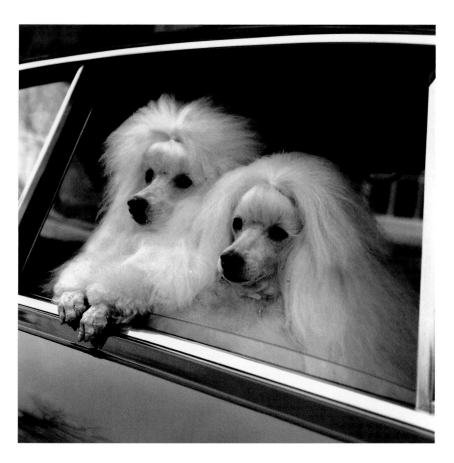

Don't make the

mistake of

treating your

dogs like humans

or they'll treat

you like dogs.

Martha Scott

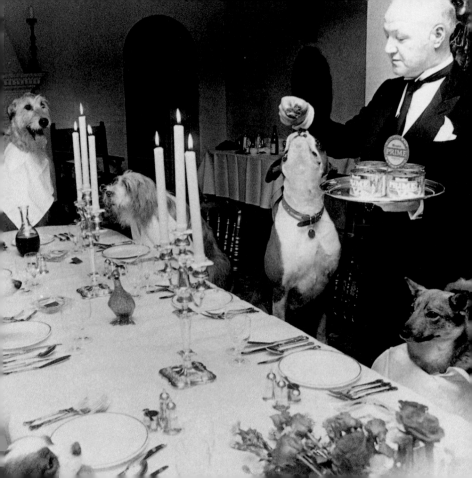

The dog…commends himself to our favor by

affording play to our propensity for mastery.

Thorstein Veblen

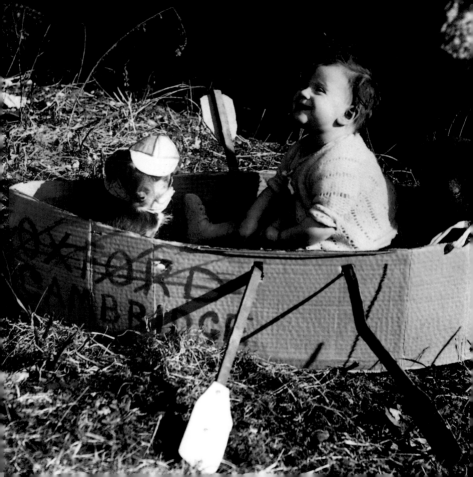

Dogs like us, we ain't such

dogs as we think we are.

Ernest Borgnine

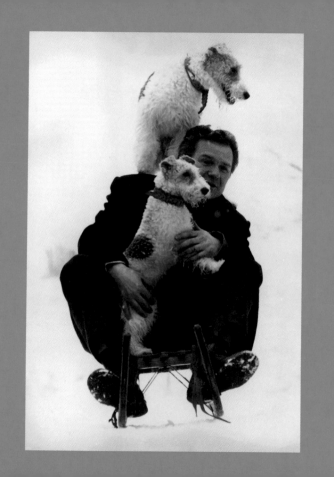

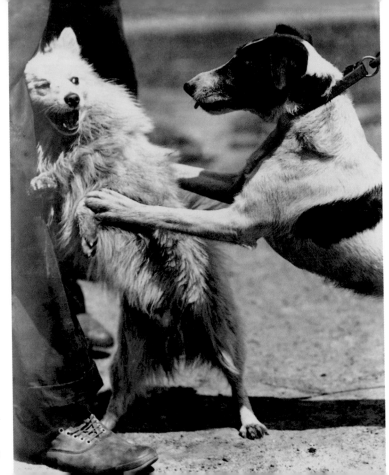

To be sure the dog is loyal. But why on that account should we take him as an example? He is loyal to men, not to other dogs.

Karl Klausœ

I say unto you again

 a dog forsaketh not his duty,

Hath might and cunning therewith

 and a great brave heart.

Gace de la Vigne

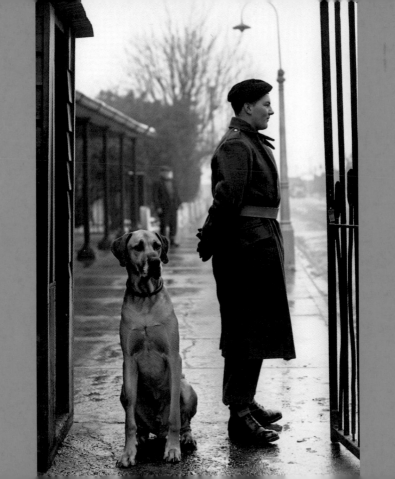

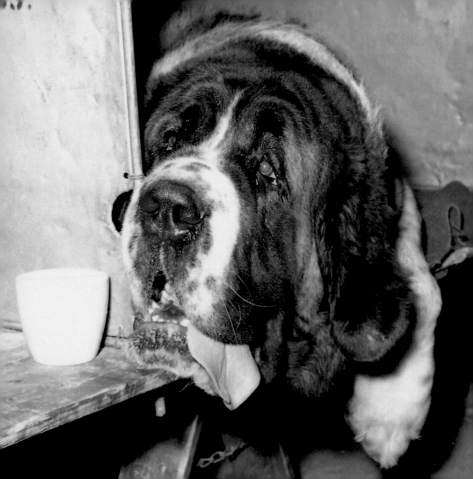

A dog is the only thing on earth that loves you

more than you love yourself.

Josh Billings

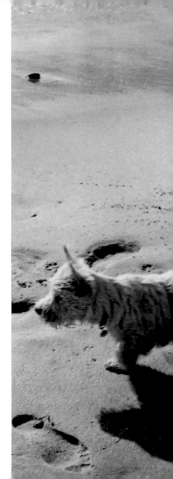

To be without a dog

is worse than being

without a song.

Henry Beetle Hough

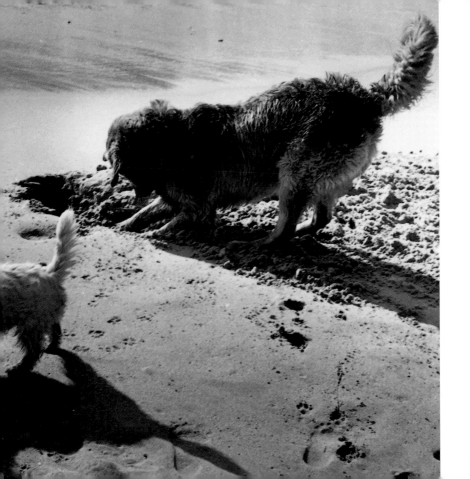

They are much superior to human beings as companions. They do not quarrel or argue with you. They never talk about themselves, but listen while you talk about yourself, and keep up an appearance of being interested in the conversation.

Jerome K. Jerome

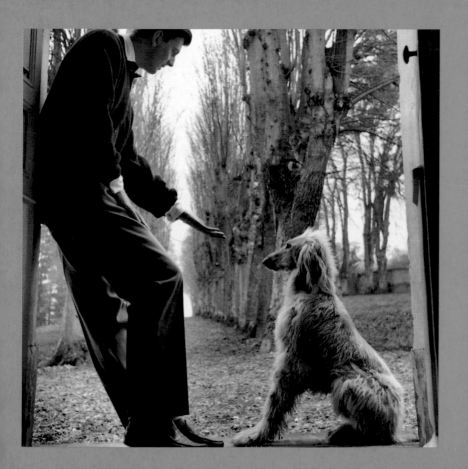

I would recommend all such

to go, say, to Harrods,

and buy a dog.

Elizabeth, Countess von Arnim

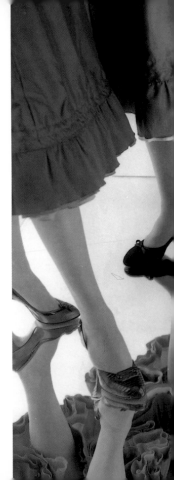

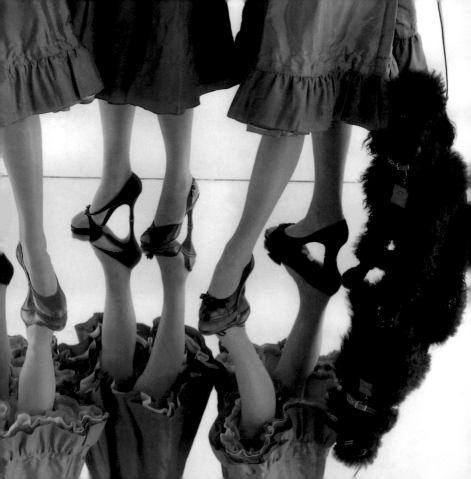

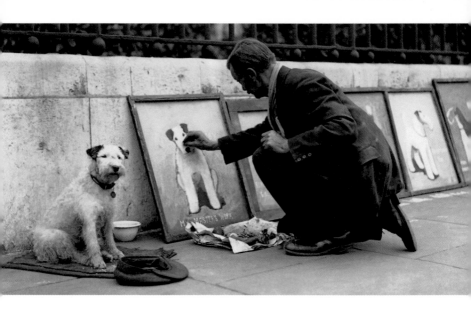

The more I see of men, the more I like dogs.

Madame Roland

Histories are more full of examples

of the fidelity of dogs than of friends.

Alexander Pope

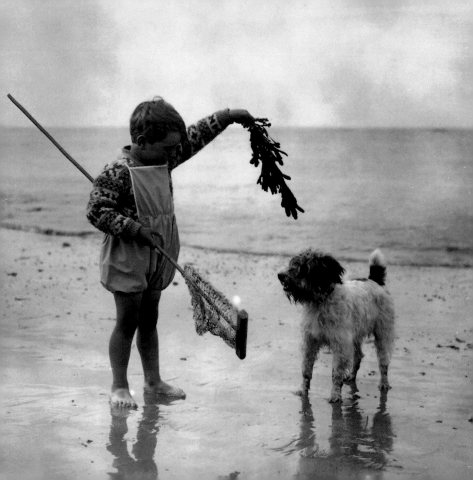

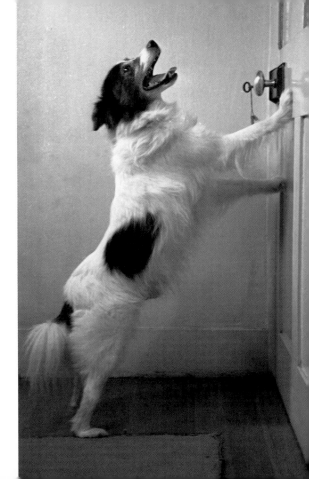

A door is what

a dog is perpetually

on the wrong side of.

Ogden Nash

The dog was created especially for

children. He is the god of frolic.

Henry Ward Beecher

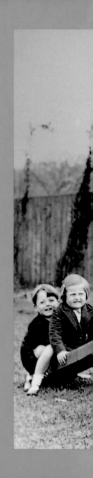

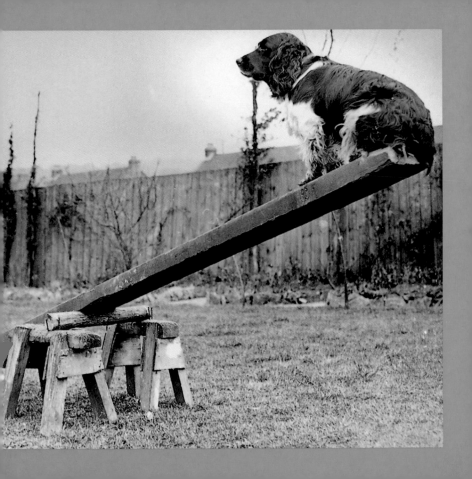

When I consider

the curious habits of man

I confess, my friend,

I am puzzled.

Ezra Pound

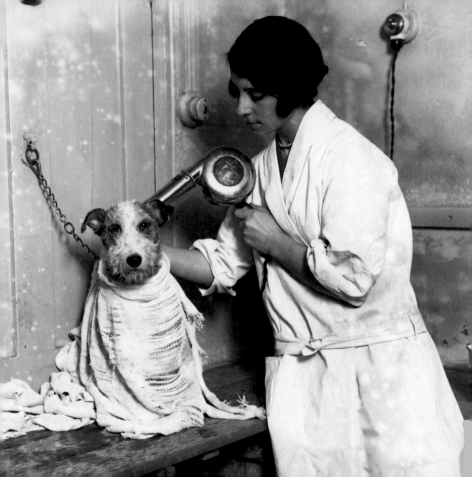

From the dog's point of view

his master is an elongated and

abnormally cunning dog.

Mabel Lousie Robinson

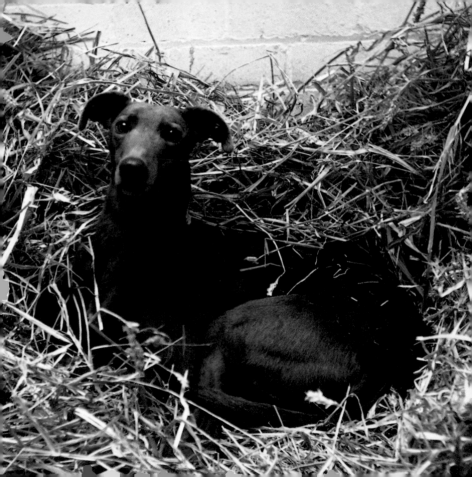

Pray steal me not; I'm Mrs. Dingley's

Whose heart in this four-footed thing lies.

Jonathan Swift

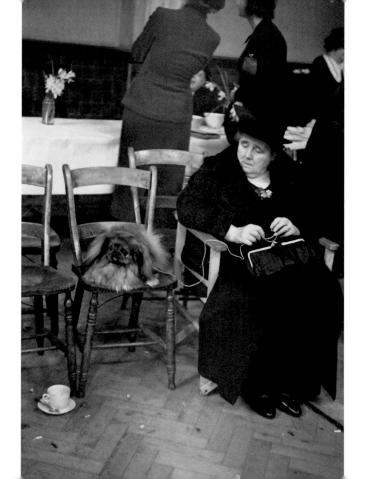

He cannot be

a gentleman

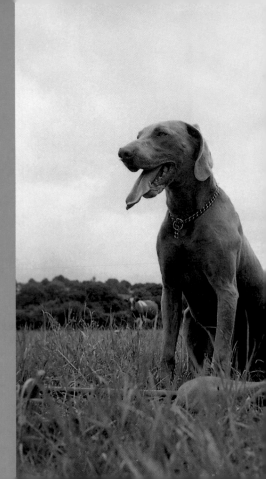

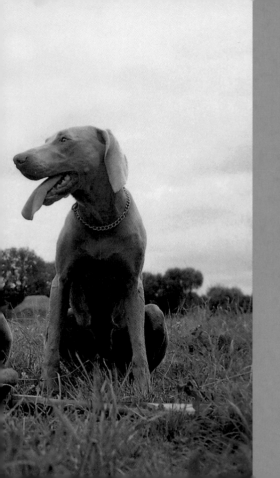

which loveth

not a dog.

John Northbrooke

65

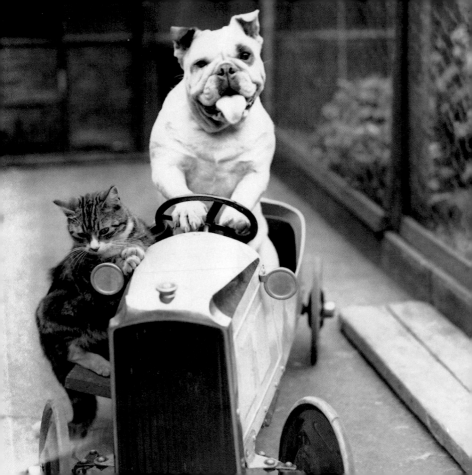

I think every family should have a dog;

it is like having a perpetual baby;

it is the plaything and crony of the

whole house. It keeps them all young.

John Brown

If you think you

have influence, try

ordering someone

else's dog around.

Anonymous

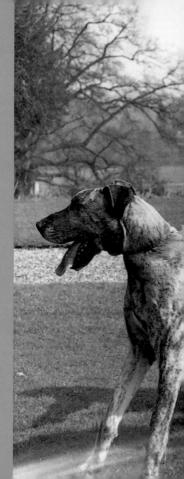

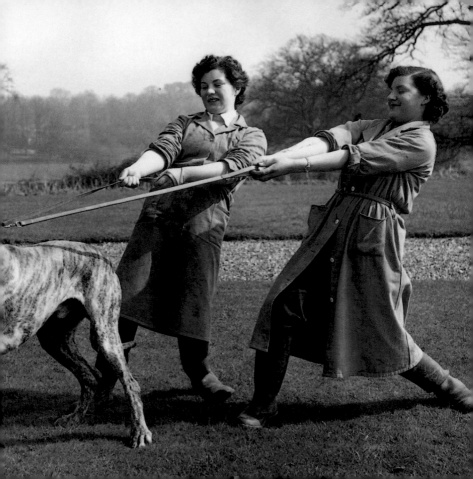

The biggest dog has been a pup.

Joaquin Miller

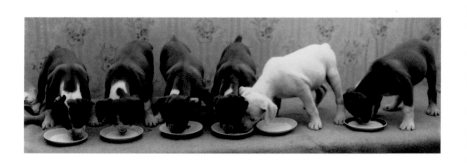

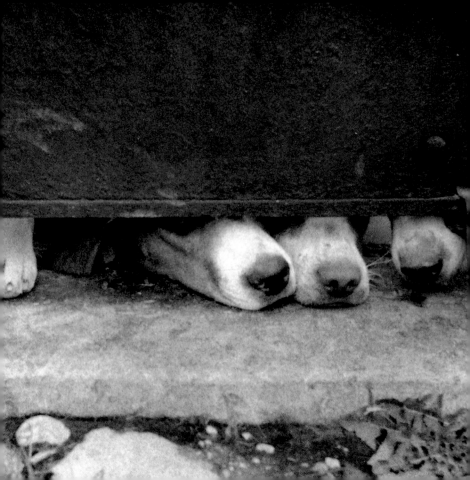

A dog's nose and a maid's knees are always cold.

Proverb

In the beginning God

created man, but

seeing him so feeble,

gave him the dog.

Anonymous

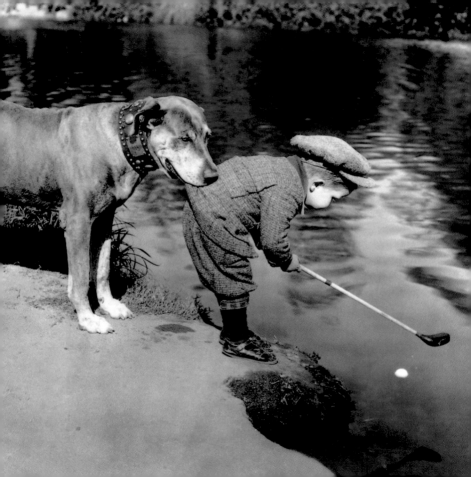

Dogs, like horses, are quadrupeds.

That is to say, they have four rupeds,

one at each corner, on which they walk.

Frank Muir

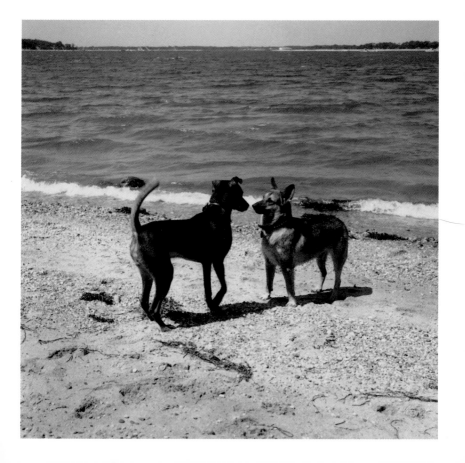

He is very imprudent, a dog is. He never makes it his business to inquire whether you are in the right or wrong, never bothers as to whether you are going up or down upon life's ladder, never asks whether you are rich or poor, silly or wise, sinner or saint. You are his pal. That is enough for him…

Jerome K. Jerome

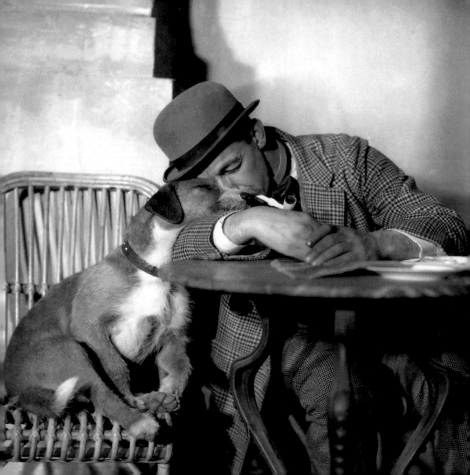

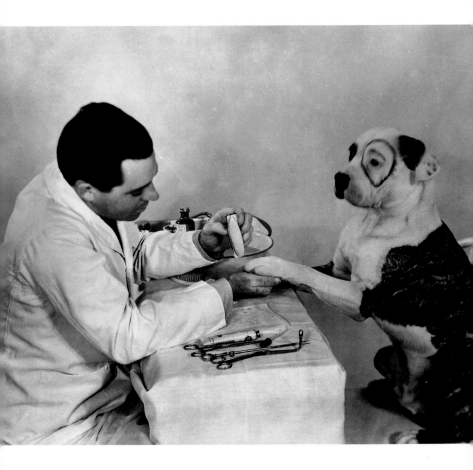

The dog has seldom been successful

in pulling Man up to its level of sagacity,

but Man has frequently dragged the dog

down to his.

James Thurber

[my dog] can bark like a congressman,

fetch like an aide, beg like a press

secretary and play dead like a

receptionist when the phone rings.

Gerald B. H. Solomon

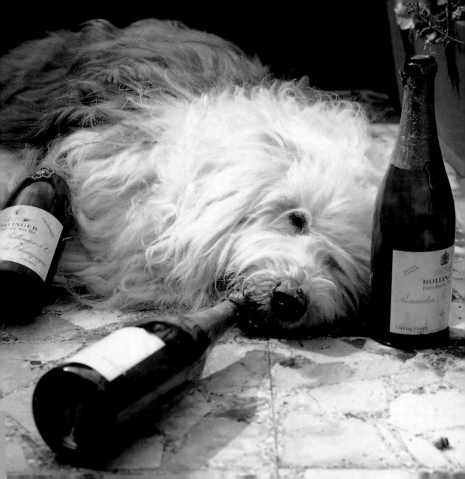

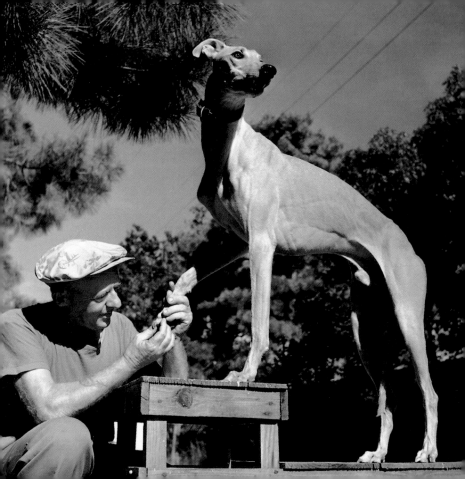

All dogs consider themselves to be Man's Best Friend. They show this by treating him with kindness and understanding, showing how to hunt things and above all, training him to do everything for the comfort and well-being of Dog.

John Tickner

Every dog is a lion at home.

Proverb

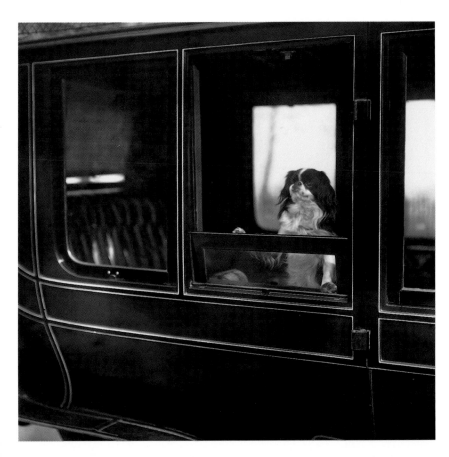

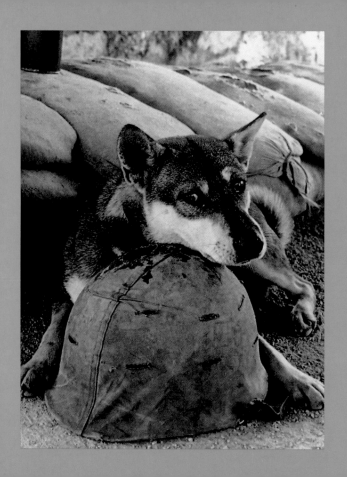

There is no faith which has never yet been broken,

except that of a truly faithful dog.

Konrad Lorenz

Let us love dogs; let us love only dogs!

Men and cats are unworthy creatures.

Marie Konstantinovna Mashkirtseff

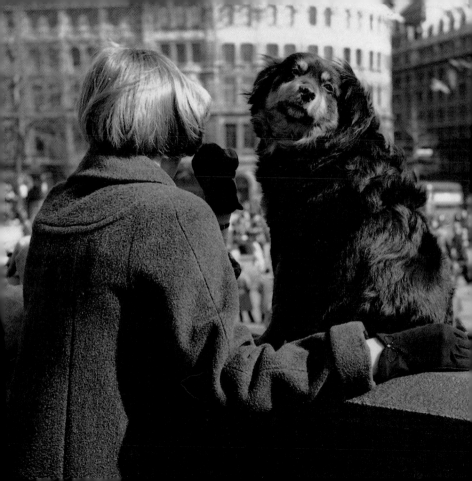

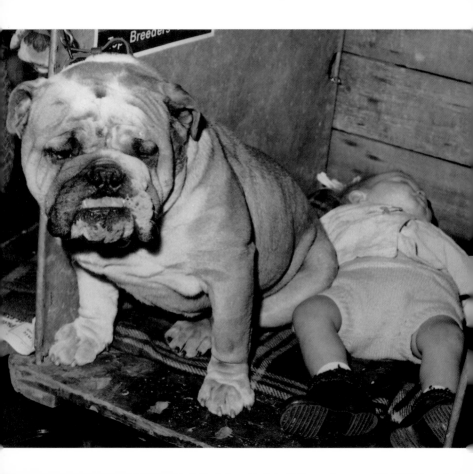

There are three faithful friends –

an old wife, an old dog and a ready dog.

Benjamin Franklin

Dogs laugh, but they laugh with their tails.

Max Eastman

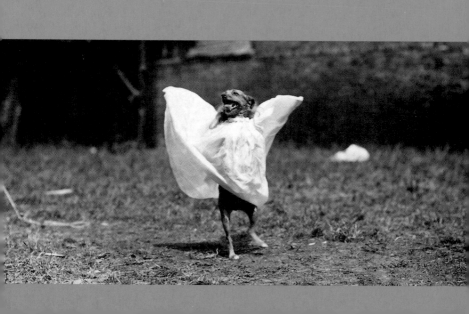

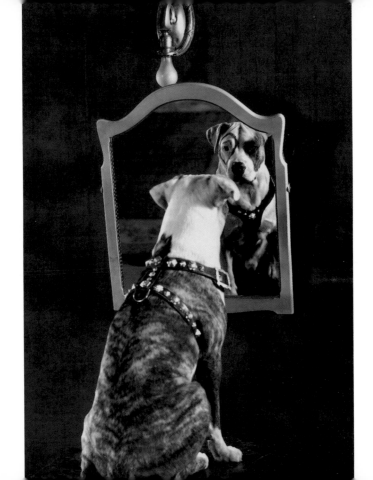

Ah, you should keep dogs

– fine animals –

sagacious creatures.

Charles Dickens

Like a dog,

he hunts in dreams.

Alfred, Lord Tennyson

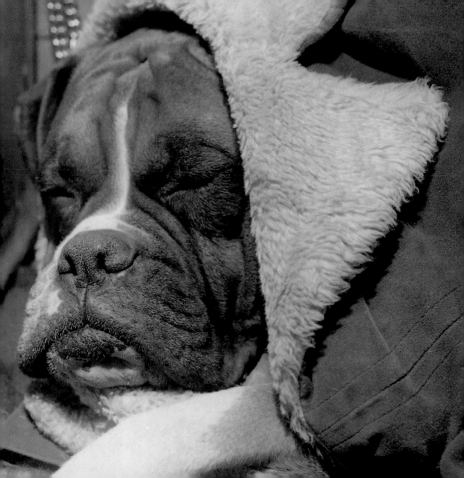

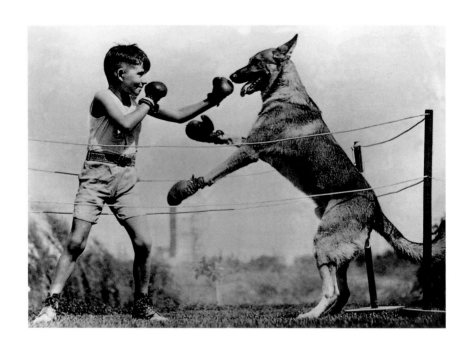

A dog teaches a boy fidelity, perseverance and

to turn round three times before lying down.

Robert Benchley

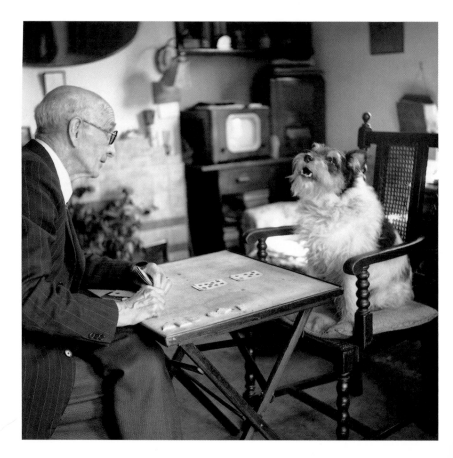

If dogs could talk,

perhaps we'd find it just as hard

to get along with them as we do with people.

Karel Capek

Let Hercules himself

do what he may,

The cat will mew

and dog will have his day.

William Shakespeare

We are alone, absolutely alone on this planet, and

amid all the forms of life that surround us, not one,

excepting the dog, has made an alliance with us.

Maurice Maeterlinck

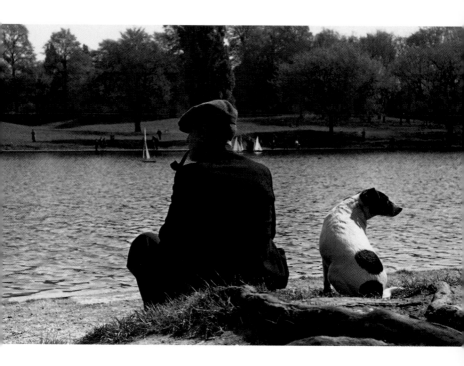

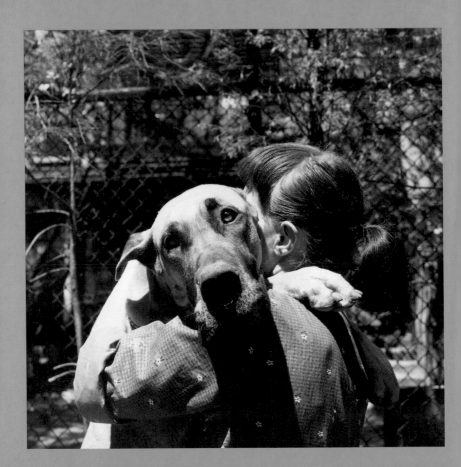

If the history of all the dogs

who have loved and been

loved by the race of man

could be written, each history

of a dog would resemble all

the other histories. It would

be a love story.

James Douglas

Picture Credits

All images Hulton Getty Picture Collection.

cover: The boxer dog mascot of the 1st Battalion Welsh Guards, 1965.

title page: A Great Dane at the Kensington Canine Society's dog show, London, UK, 1933.

page 4: A child and puppy make friends on a beach, circa 1955.

page7: A cyclist finds a novel way to carry her dog, Holland, 1954.

page 9: A young boy cuddles his pet terrier, circa 1955.

page 10: A little girl and her dog beside Kexinn Pond, Bromley, 1967.

page12: Wally Kilminster with his dog in the dressing rooms at Wembley Stadium, London, UK, 1934.

page 15: A yawning terrier, 1953.

page 17: A Cumbrian shepherd with his dog, 1943.

page 18: Two Jack Russell terriers, 1939.

page 21: "Beaming Blunderbus", a bulldog at a Belfast dog show, 1912.

page 23: A young Boston terrier asleep in its owner's bed, 1962.

page 25: As title page.

page 26: A woman gets her Scottish terrier to beg on a beach, 1935.

page 28: A chihuahua's-eye view of Cruft's dog show, London, UK, 1967.

page 31: Poodles, Stanlyn Cleopatra and Miradel Cleo, on their way to Cruft's dog show, London, UK, 1969.

page 33: A canine banquet to launch a new brand of dog food, Knightsbridge, London, UK, 1975.

page 35: A baby and dog change their allegiance before the annual Oxford versus Cambridge boat race, 1935.

page 37: Two dogs enjoy a ride on their owner's sledge, Paris, France, circa 1955.

page 38: Dogs fighting, 1932.

page 41: Colonel R E Crompton and his Great Dane, "Tigger", stand guard, Gravesend, UK, 1953.

page 42: A St Bernard at the Richmond Championship dog show, London, UK, 1960.

page 44/45: Dogs playing on the beach, Bournemouth, UK, circa 1960.

page 47: An Afghan hound and owner, circa 1990.

page 48/49: A poodle adds a touch of chic to shoes made by H & M Rayne, shoemakers to the British Royal Family, 1954.

page 50: A pavement artist makes a chalk drawing of his dog, 1931.

page 53: A child with his dog, Lowestoft, UK, 1926.

page 54: A circus-trained dog closes a door, 1949.

Library of Congress Cataloging-in-Publication Data

CIP data tk

Printed in China

4 5 6 7 8 9 10

Cover design: John Casey
Design: WDA
Text and picture research: Suzie Green
Series Editor: Elizabeth Carr